For _____

From _____

Because there's no place
quite like home.

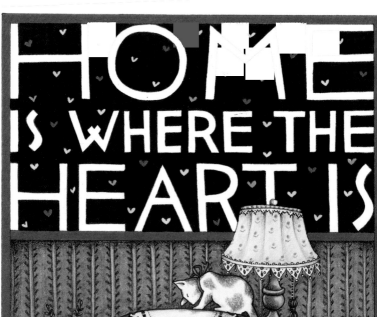

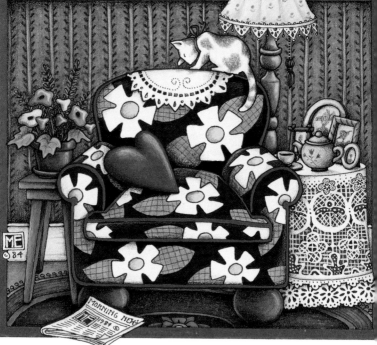

Home Is Where the Heart Is

Illustrated by
Mary Engelbreit

Andrews and McMeel
A Universal Press Syndicate Company
Kansas City

 is a registered trademark of Mary Engelbreit Enterprises, Inc.

10 9 8 7 6 5 4 3

ISBN: 0-8362-2299-7

Written by Jan Miller Girando

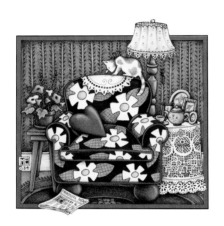

Home Is Where
the Heart Is

Home is where the heart is.
It's a warm, protective haven
where you're comfortable
and feel that you belong,
where you're genuinely valued
for your talents and uniqueness
and accepted whether things
go right or wrong.

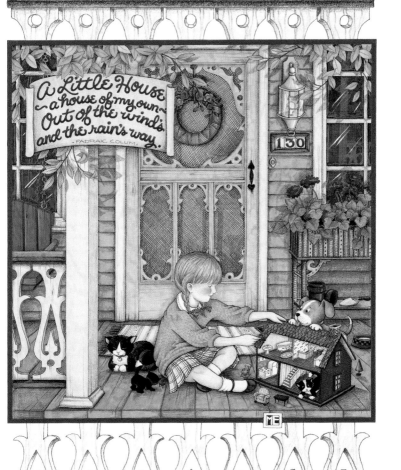

A Little House
~a house of my own~
Out of the wind's
and the rain's way.
· PADRAIC COLUM ·

130

More than just an address,
home is where you feel most needed
and the place you can relax
without concern.

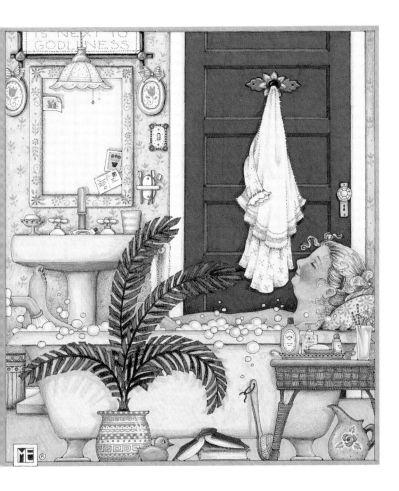

More than just location,
home is anywhere you share with
those you care about,
who love you in return.

EVERYONE
NEEDS THEIR OWN
SPOT.

· ROBERT WHALEN ·

Home may be the seashore,
the majestic, snow-capped mountains,
or a country cottage where you can unwind.

A Day at the Beach

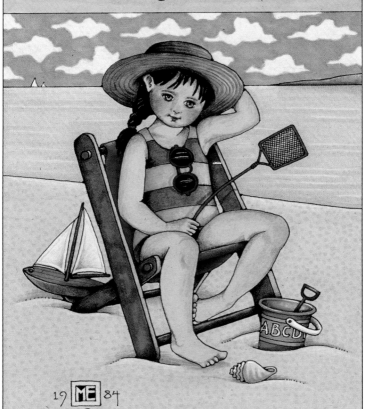

19 ME 84

It can be a bustling city
or the unpretentious heartland—
anyplace at all that brings you
peace of mind.

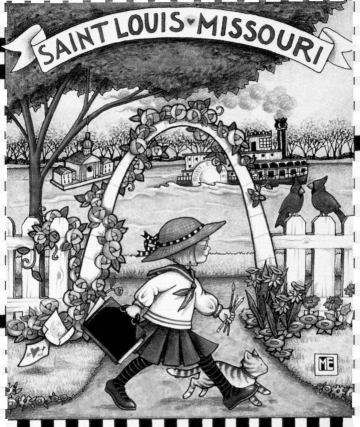

SAINT LOUIS ♥ MISSOURI

YOU AIN'T SEEN
C U T E
TIL YOU'VE SEEN ST. LOUIS

Home is where you start from
on your journey toward tomorrow—
it's the compass that helps
guide you to your goal.

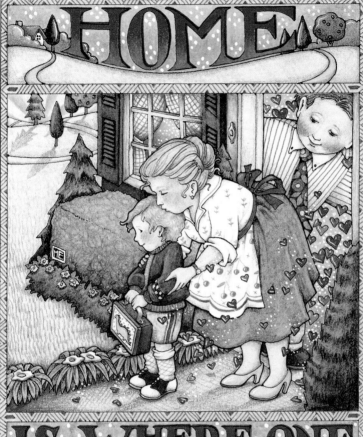

HOME

IS WHERE ONE STARTS FROM

T.S. ELIOT

It's the touchstone you return to
when your life is filled with changes
and you need some time to
redefine your role.

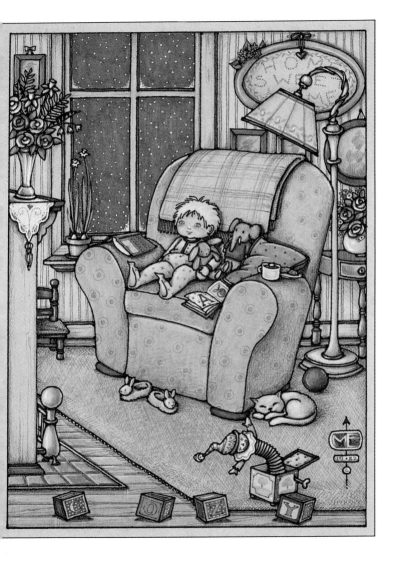

Home is where there's laughter,
where your oldest clothes are welcomed,
where relaxing is the order of the day,
where there are no "should's" and "ought to's"
and you do what makes you happy.
If you choose to be indulgent,
that's okay!

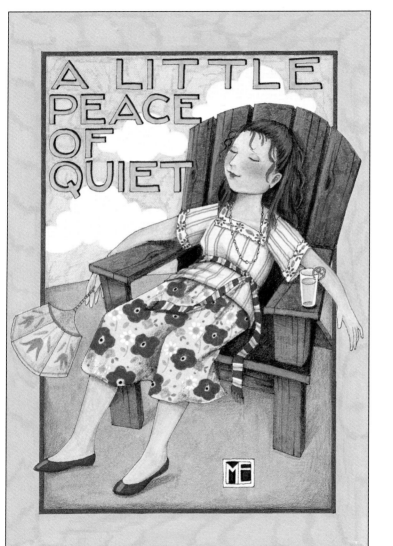

Home can be a place for
quiet thoughts and inspiration,
where priorities are questioned
and assessed ...

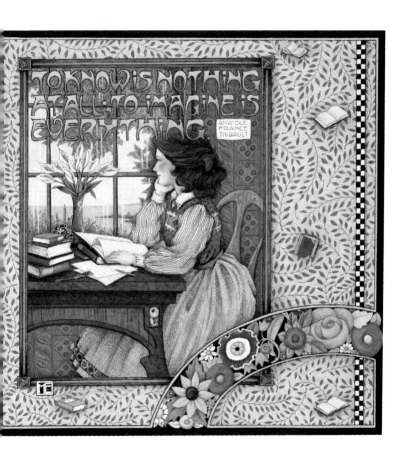

TO KNOW IS NOTHING AT ALL; TO IMAGINE IS EVERYTHING.

ANATOLE FRANCE THIBAULT

... where you clear your head of cobwebs,
sweep the worries from your doorstep
and emerge again refreshed and at your best.

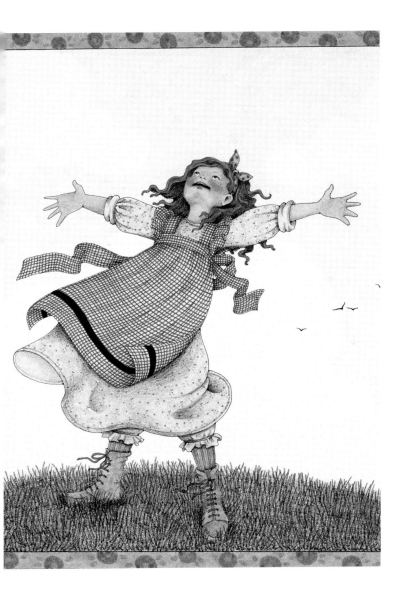

Whether overflowing with the warmth of friends and family or protected as an undisturbed retreat ...

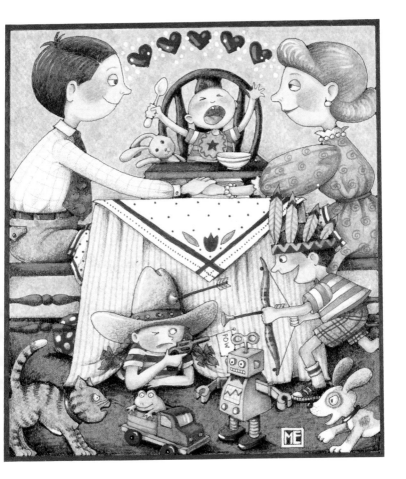

... home can feed your spirit
and invigorate your senses.
It's your very own
address on Easy Street!

THE PRINCESS OF QUITE·A·LOT

It's just around the corner
from wherever life may take you.
It's around the bend,
wherever you may roam.
Close your eyes and you can be there,
for the place your heart returns to
is the place that you'll
forever call your home.

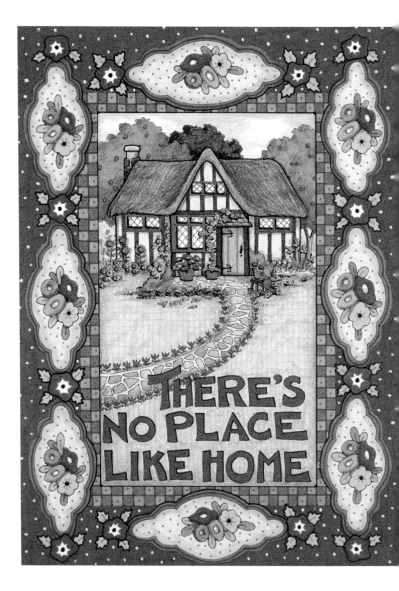

THERE'S NO PLACE LIKE HOME